Dogs in the Bath

Dogs in the Bath

The Ultimate Collection

BLACK & WHITE PUBLISHING

First published 2016
by Black & White Publishing Ltd
29 Ocean Drive, Edinburgh EH6 6JL

1 3 5 7 9 10 8 6 4 2 16 17 18 19
ISBN: 978 1 78530 061 5
Text © Black & White Publishing 2016

The publisher has made every reasonable effort to contact copyright holders of images in this book. Any errors are inadvertent and anyone who for any reason has not been contacted is invited to write to the publisher so that a full acknowledgment can be made in subsequent editions of this work.

A CIP catalogue record for this book is available from the British Library.

Typeset by Creative Link, North Berwick

Images used on p2, p4, p6, p8, p10, p11, p14, p22, p23, p24, p29, p32, p40, p41, p44, p47, p54, p56, p58, p59, p60, p62, p64, p66, p72, p73, p84, p86, p88, p90, p92, p94, p98, p100, 106, p110, p111, p112, p116, p118, p119, p120, p122, p124, p126, p127, p132, p136, p138 © Shutterstock

Images used on p12, p16, p17, p18, p20, p26, p28, p30, p34, p35, p36, p38, p42, p46, p48, p50, p52, p53, p65, p68, p70, p74, p76, p78, p80, p81, p82, p89, p97, p102, p104, p105, p108, p114, p128, p130, p134, p135, p140 © iStock

Introduction

It's no secret that most dogs do not enjoy bath time. It can be confusing, overwhelming and bewilderingly bubbly. And most of all, very, very wet. Once they go in, they aren't coming out until they are thoroughly bedraggled, disorientated, and smelling much, much sweeter. But whether they love it, hate it, or are simply confused by it, every dog must face bath time!

Most owners don't enjoy it much either but with *Dogs in the Bath* you can enjoy the whole experience at arm's length, without any of the splashing. From Pugs to Pomeranians, Chihuahas to Bulldogs and Spaniels to Labradors, no dog is spared.

Capturing dogs of all shapes, sizes, and emotional dispositions, this collection is a fascinating, hilarious, and heart-warming homage to our beloved canine companions and the neverending quest for clean dogs. In a unique take on the experience of dog ownership, bedraggled pooches of all shapes and sizes are captured at their most entertaining. Containing over one hundred photos and witty captions, this book is a must-have for any dog lover and shows that doggy bathtime really can be fun – as long as it's someone else's dog!

Well, that was
traumatising

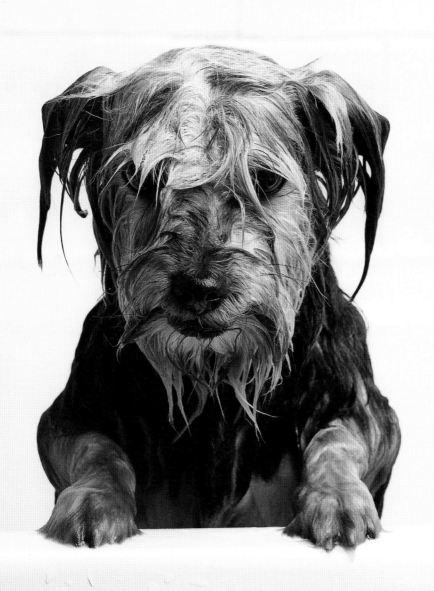

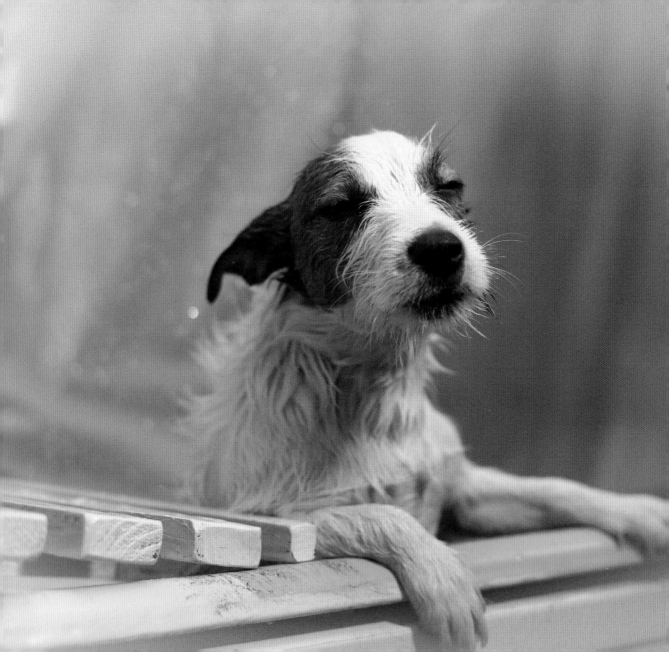

I can't even look at you right now

I suppose you
think this is some
sort of JOKE

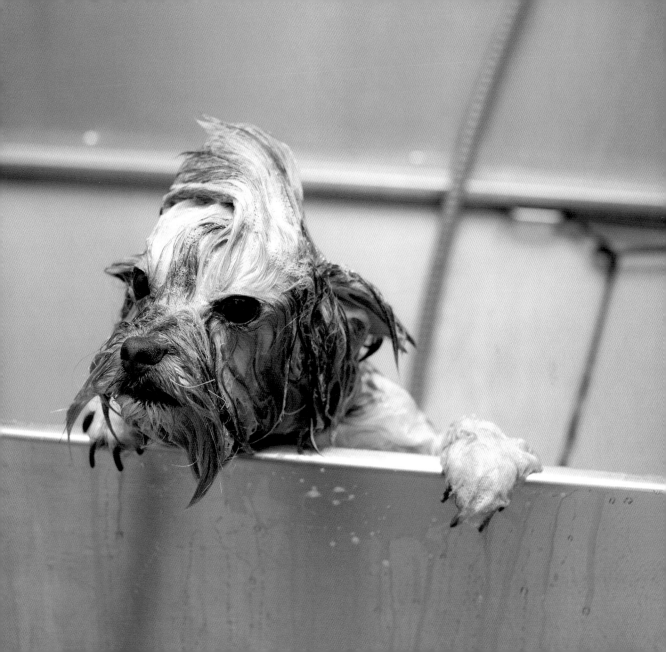

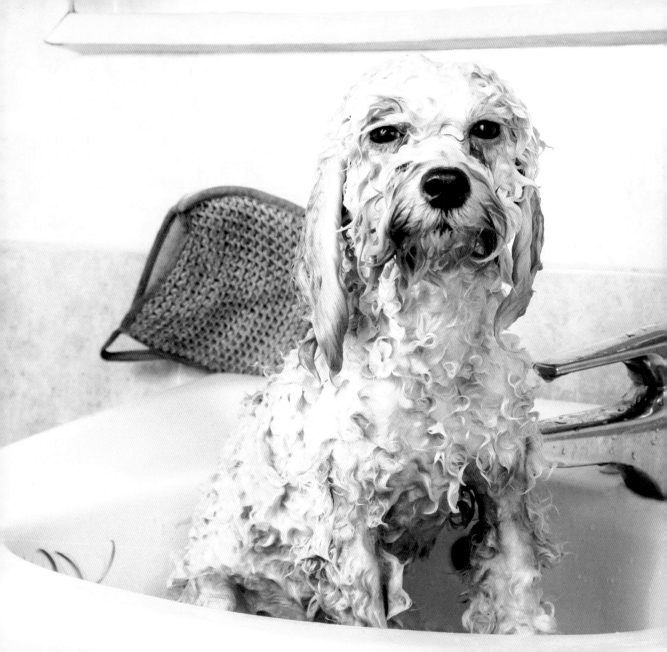

Dignity.
Always,
dignity.

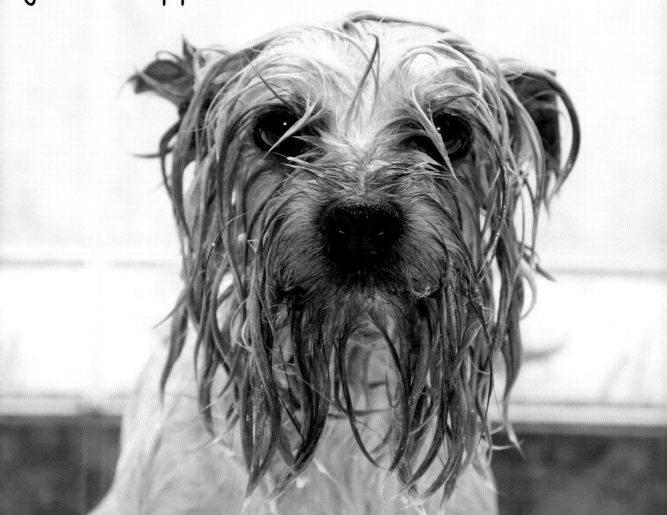

I'm not angry with you,
just disappointed

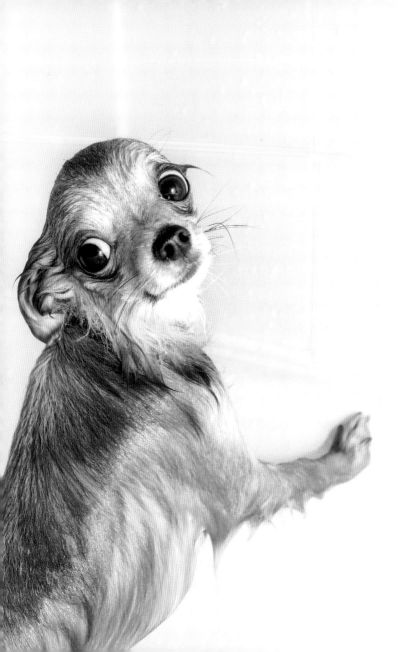

Make sure
you get my
good side!

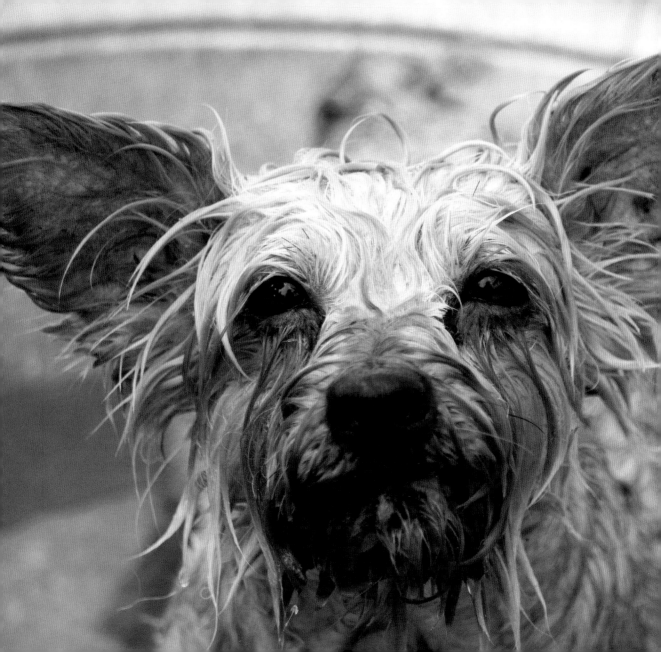

If this was supposed to make me look better, why do I look like Yoda?

You can never tell
anyone about this

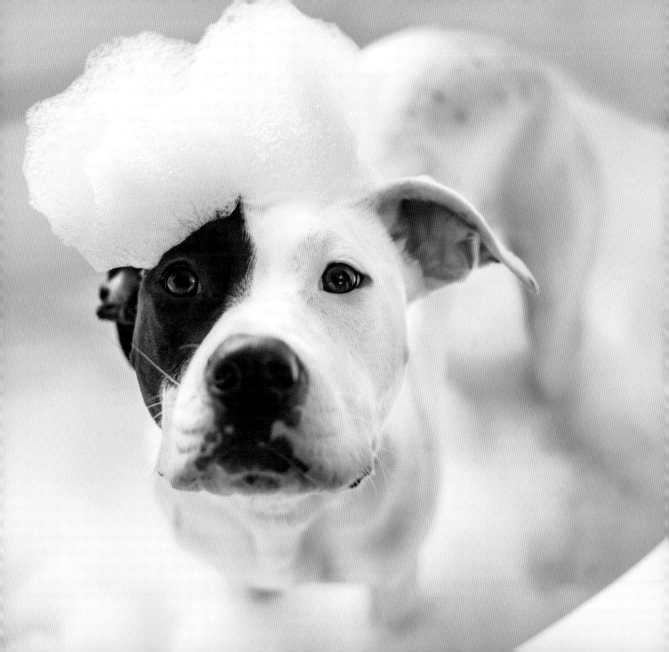

Can I go
play now?

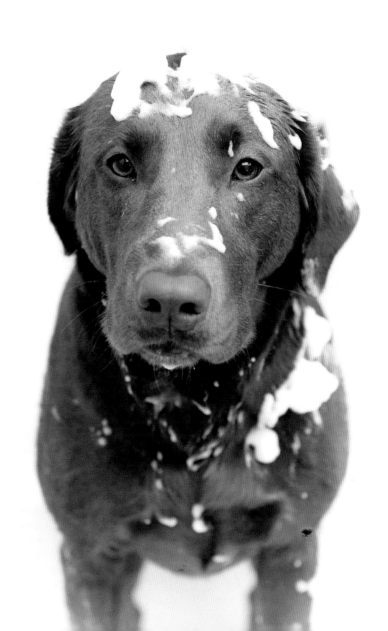

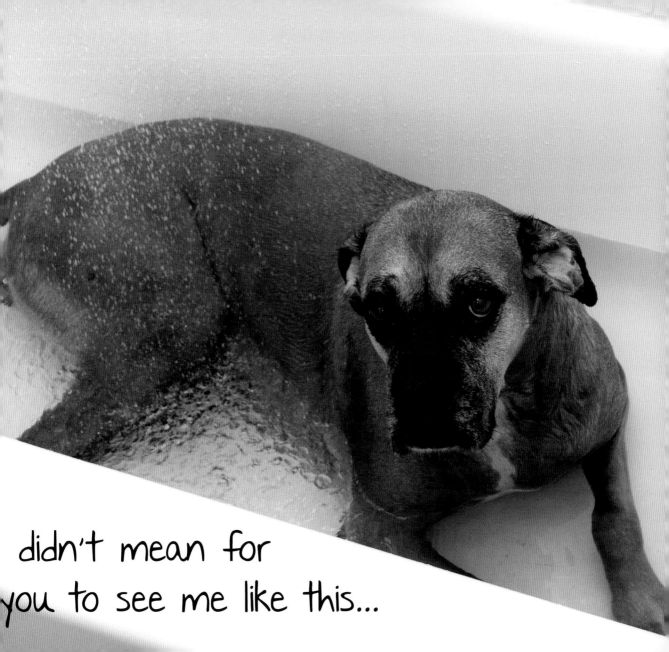

Bath times
are better
with a buddy

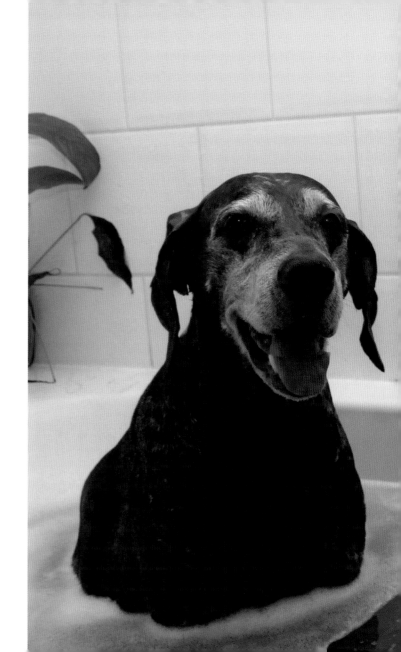

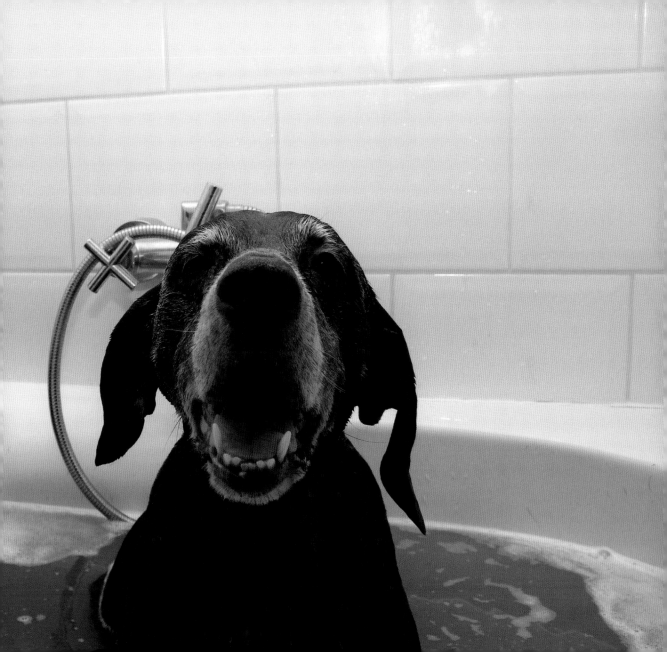

Cheese.

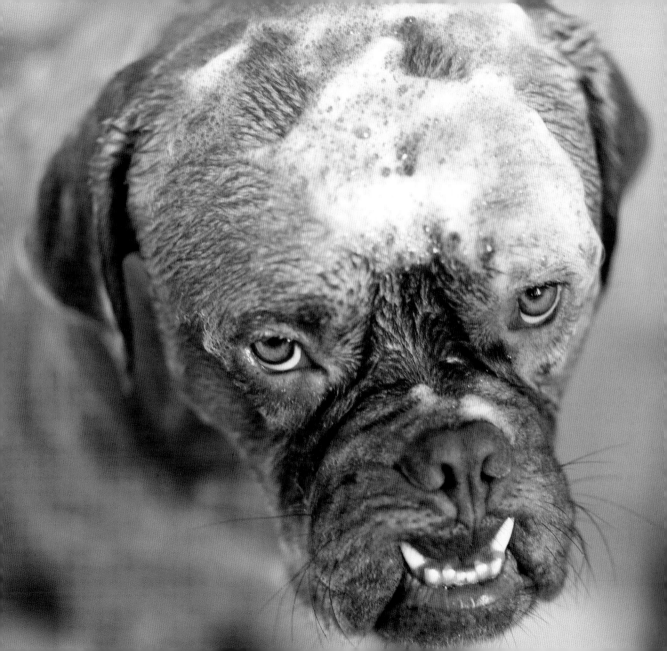

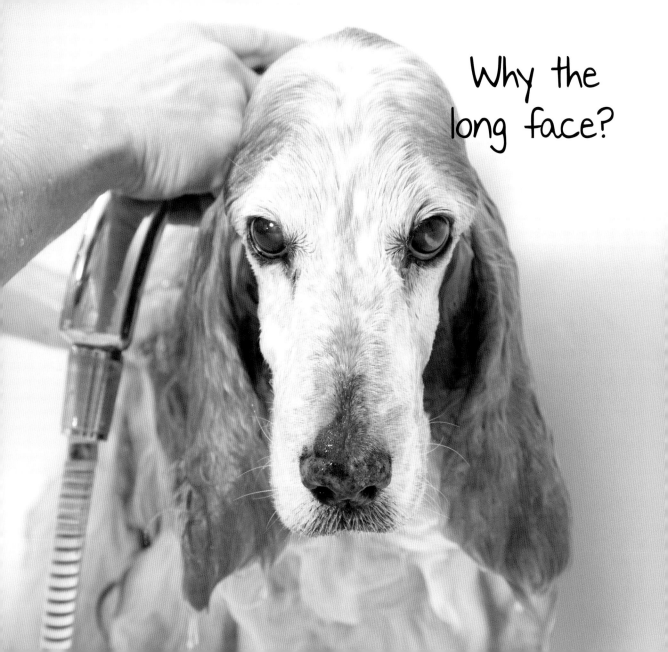

Why the long face?

Maybe no one will notice the mud on my face?

I really can't enjoy
this head massage
while there's so much
shampoo in my nose

I specifically
requested a bath

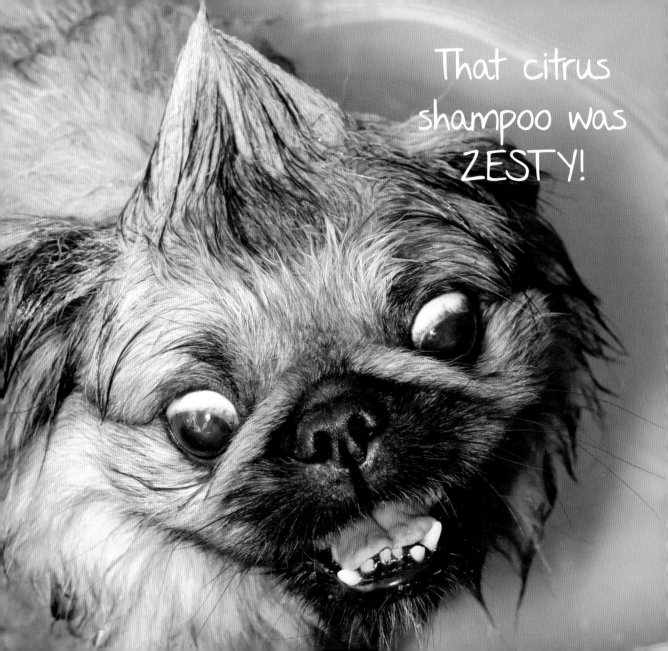

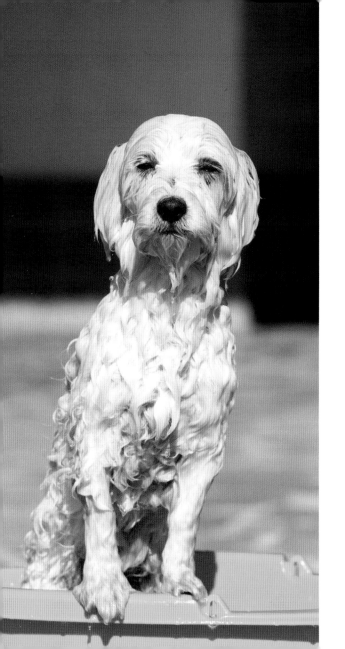

You can expect
the silent
treatment until
I look cute and
fluffy again

I think the bubbles
have gone straight
to your head!

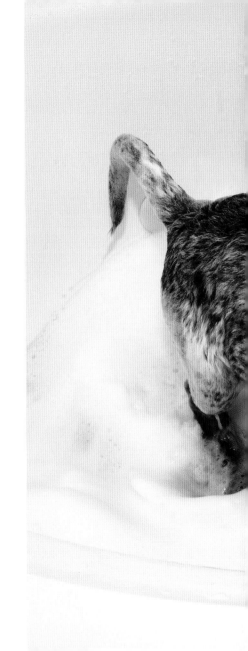

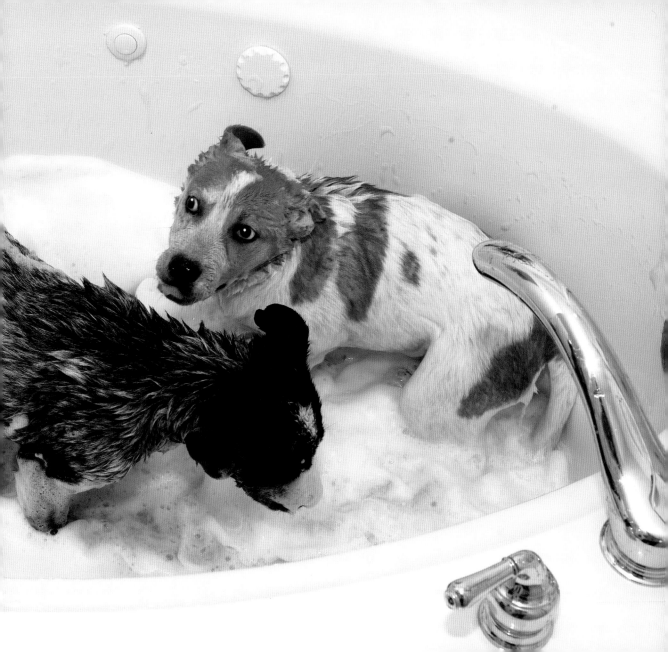

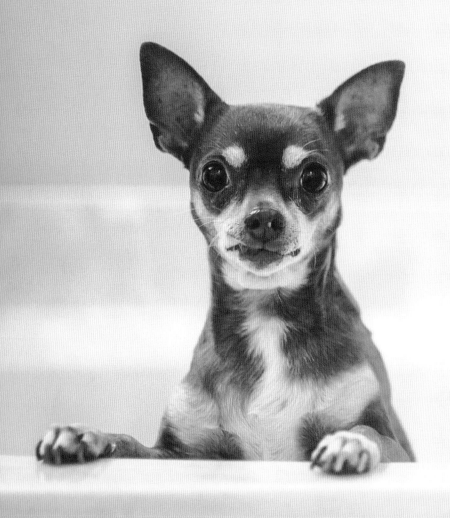

Are the ducks
supposed to make
me feel better
about this?

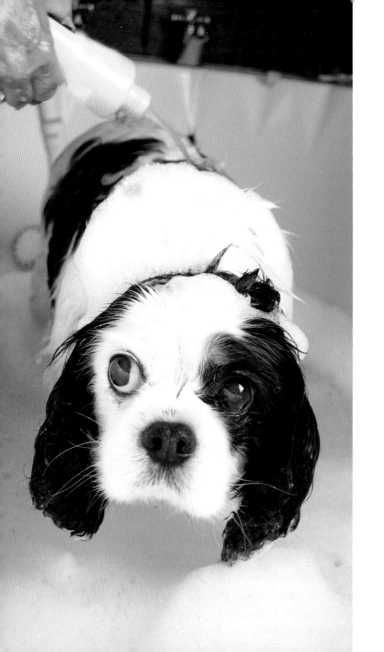

Don't forget
to clean behind
my ears

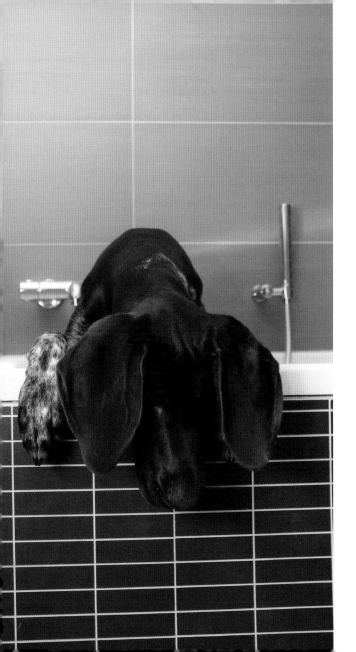

I am going to allow this back rub, but just know that I don't trust you, human

What is this tiny
swimming pool?

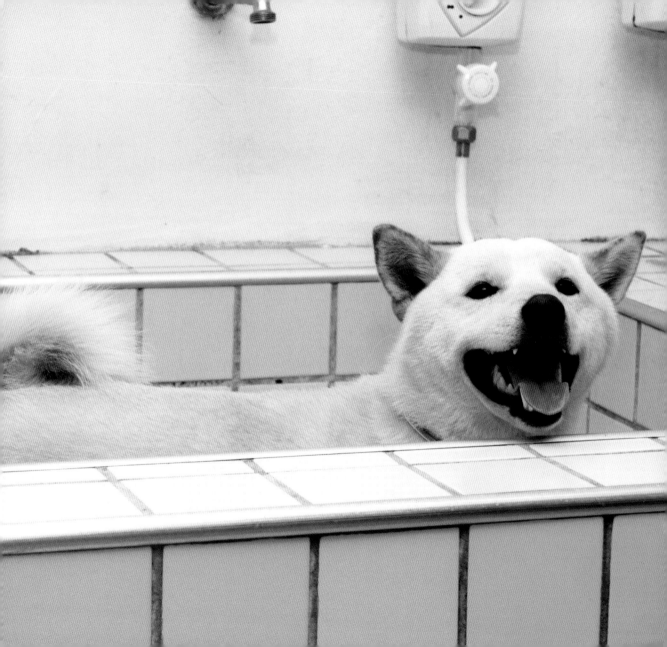

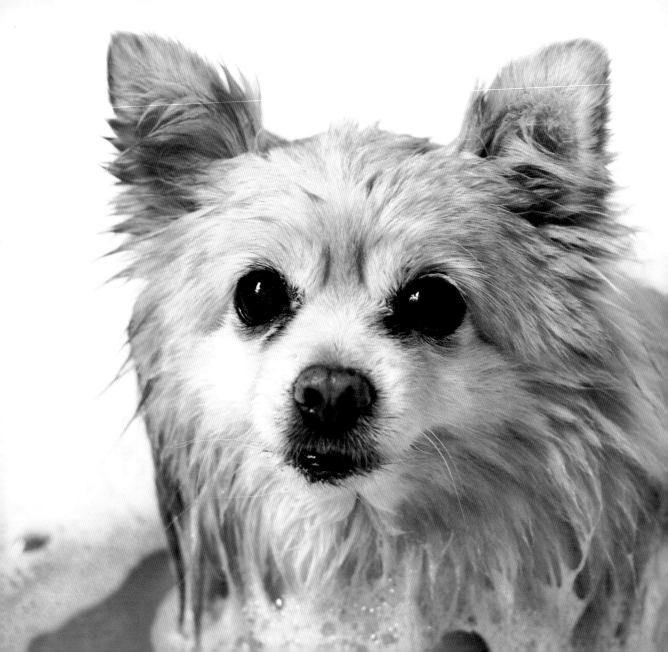

I am swimming in a
sea of emotion

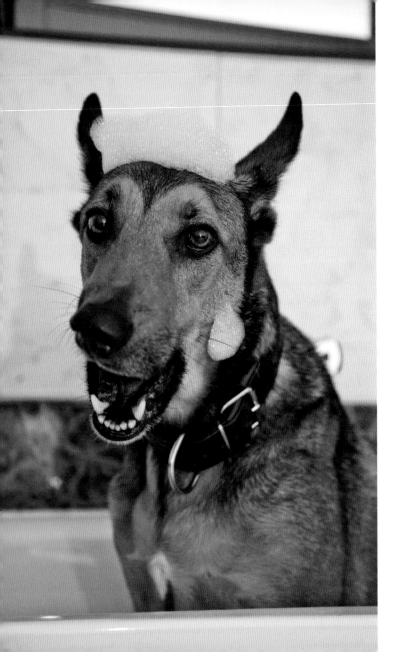

You ain't nothing but a hound dog

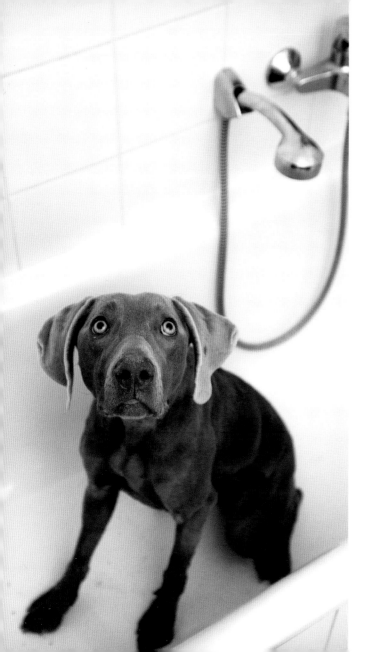

I need you
to just
put down
the Herbal
Essences and
step away
from the
bath tub

41

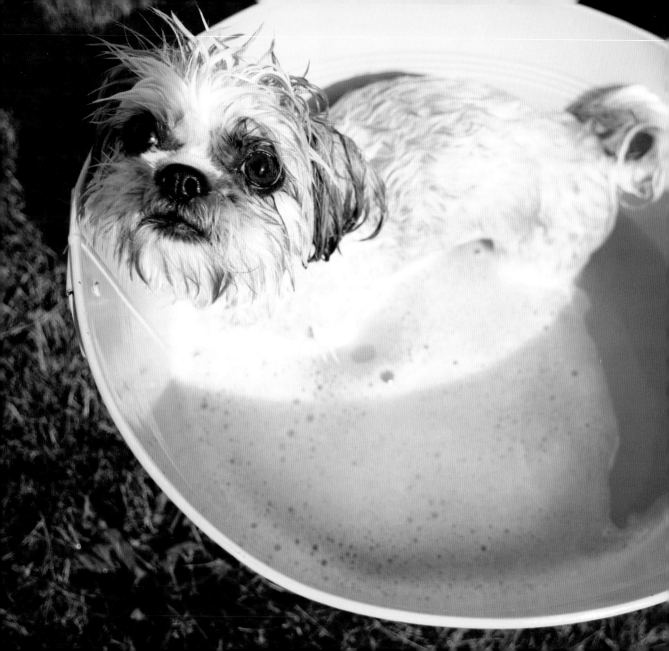

I feel like you may have exaggerated about your 'jacuzzi'

It doesn't have
to end this way

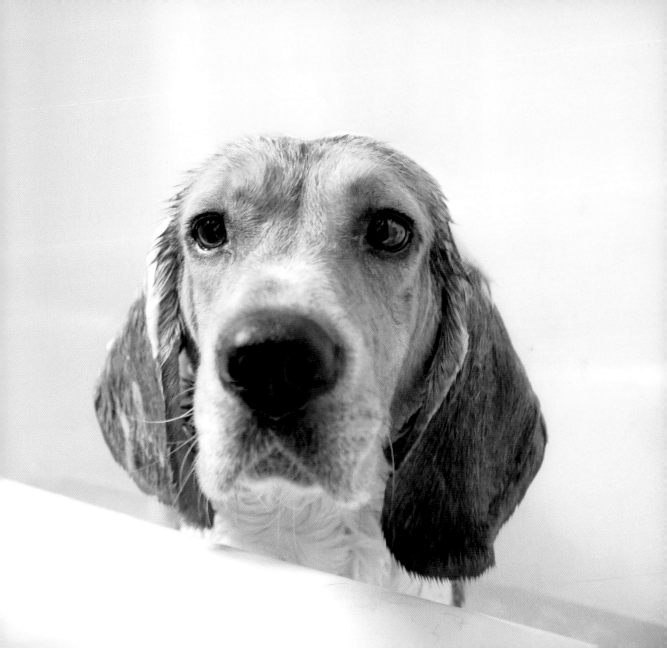

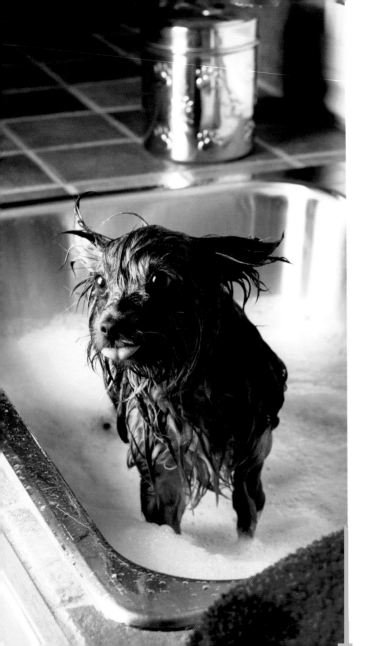

This has all been terribly nice, but you seem to have mistaken me for a dirty dish

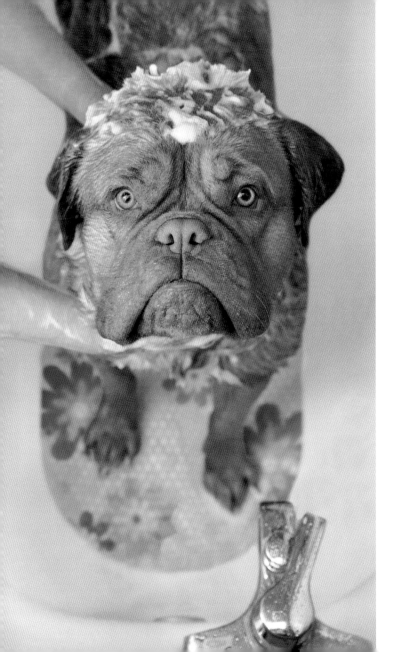

In case you couldn't tell, I do not appreciate this

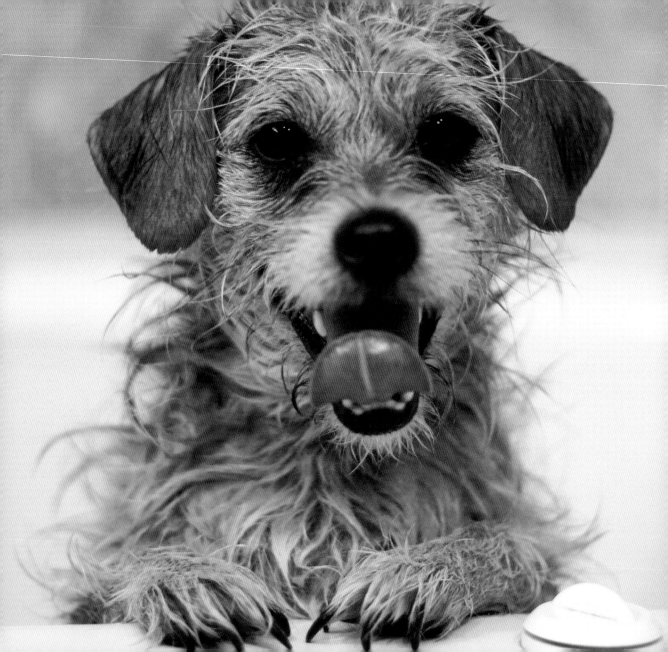

I'm ready for my manicure

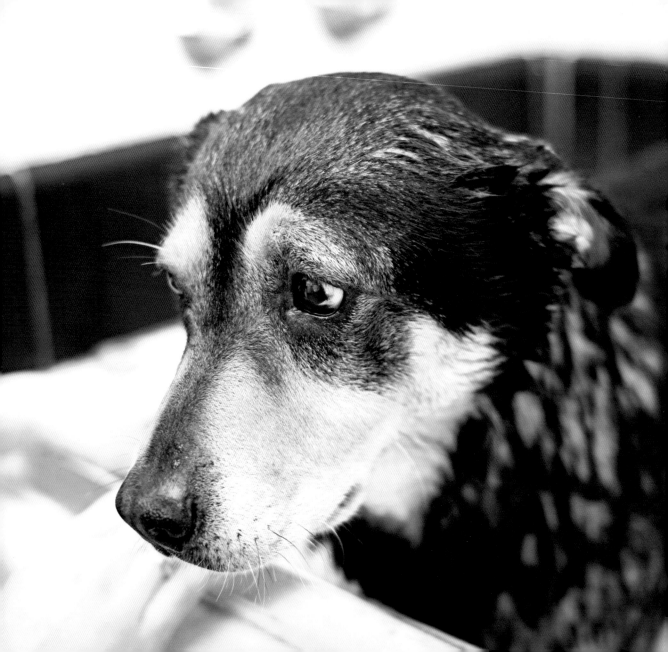

What do you mean you've run out of bubble bath?

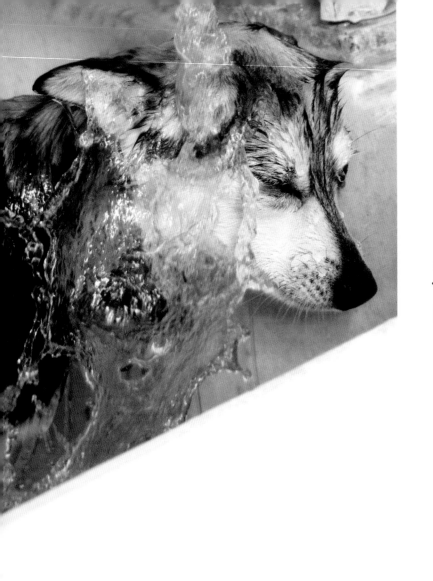

A bath is a good place to wonder where your life went wrong

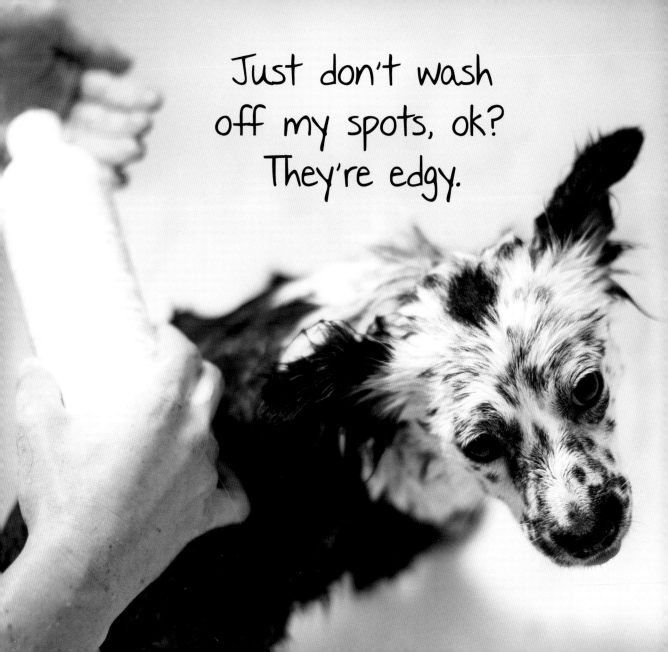

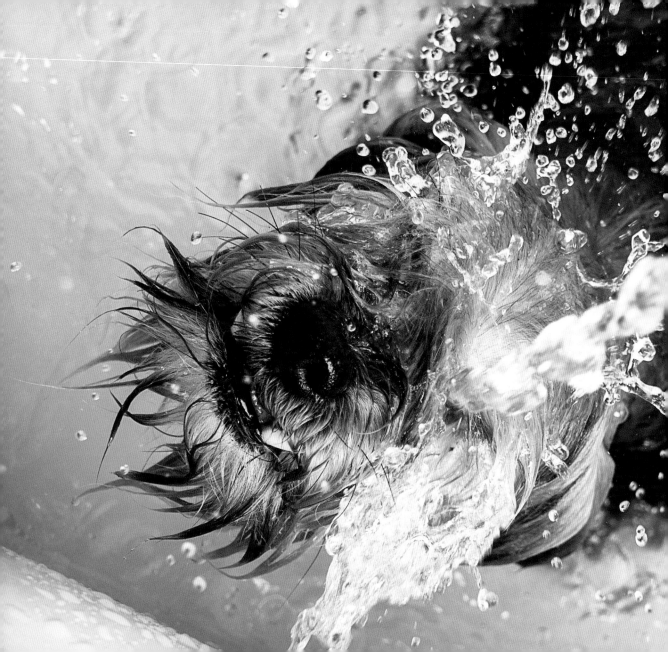

I DON'T
THINK
YOU'RE
DOING IT
RIGHT!!

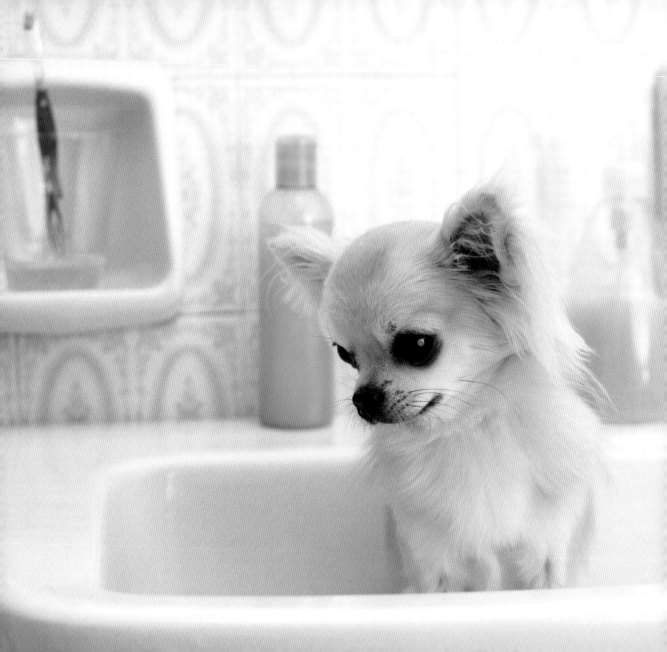

Don't try to stop me - I'm gonna jump

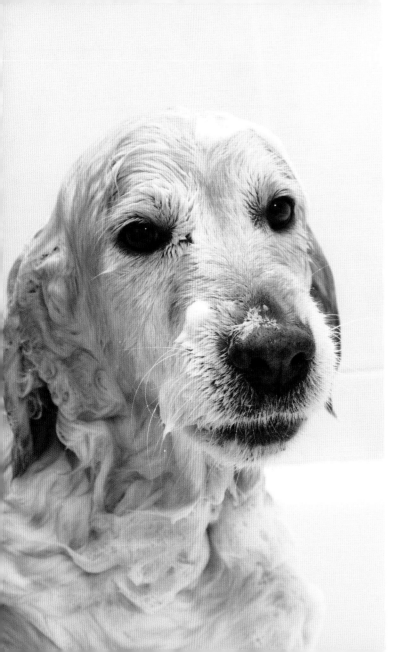

I am smiling, I just don't feel very pretty right now

Beginning to
lose my cool
over here...

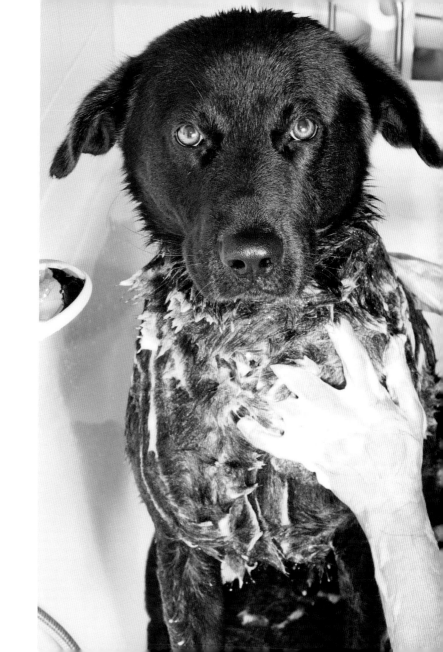

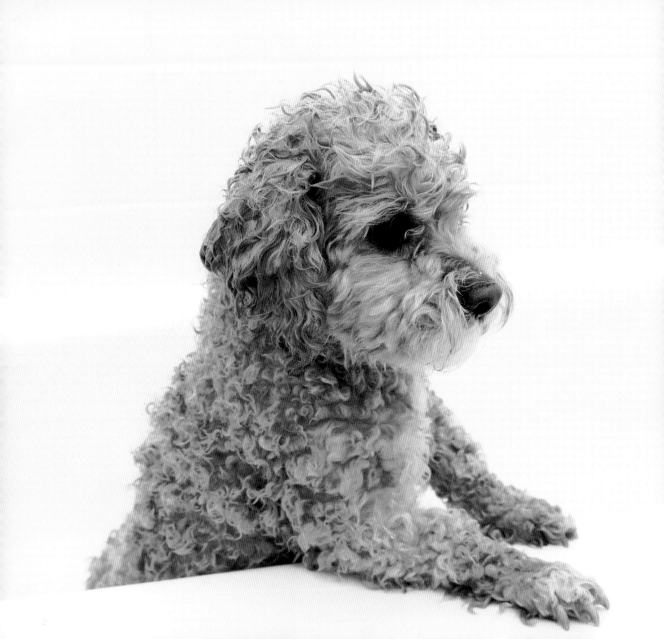

No, no, the
lavender salts!

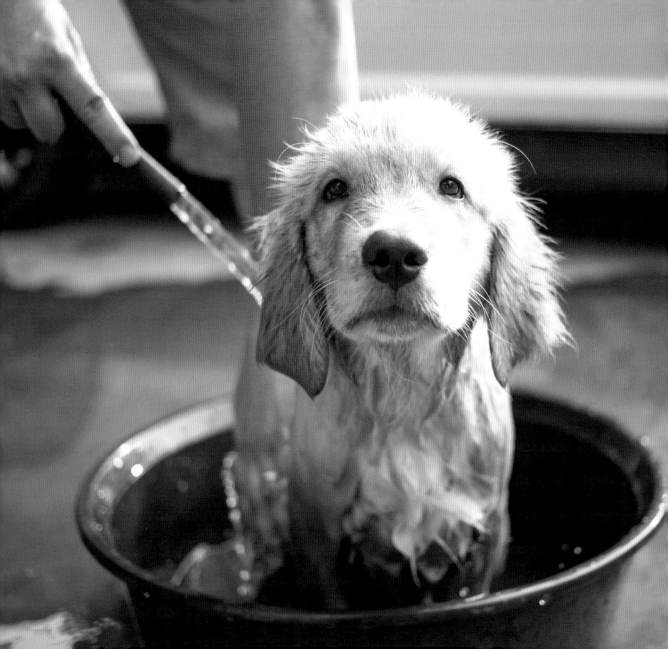

I don't know why you've done this, but I'm 100% going to poop in your shoes the second this is over

I'm still cute,
though, right?
Right?!

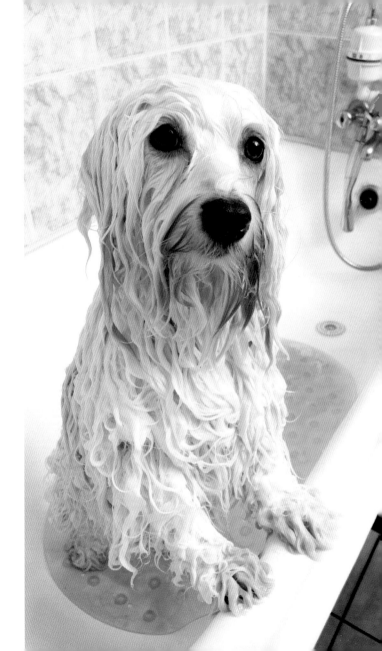

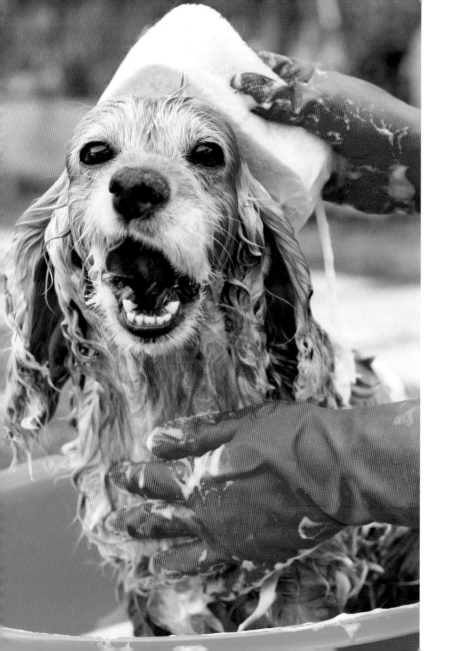

It takes a
lot of work
to look this
good

I said I wanted a chic hairstyle, not a sheep hairstyle!

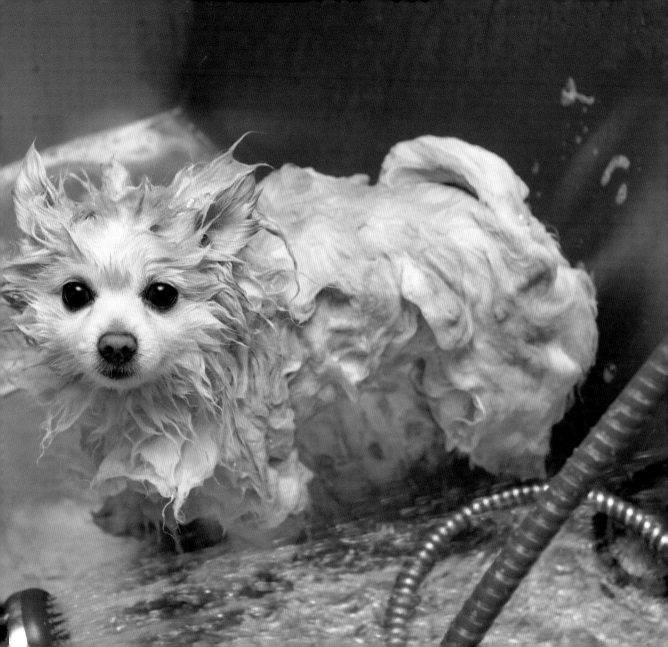

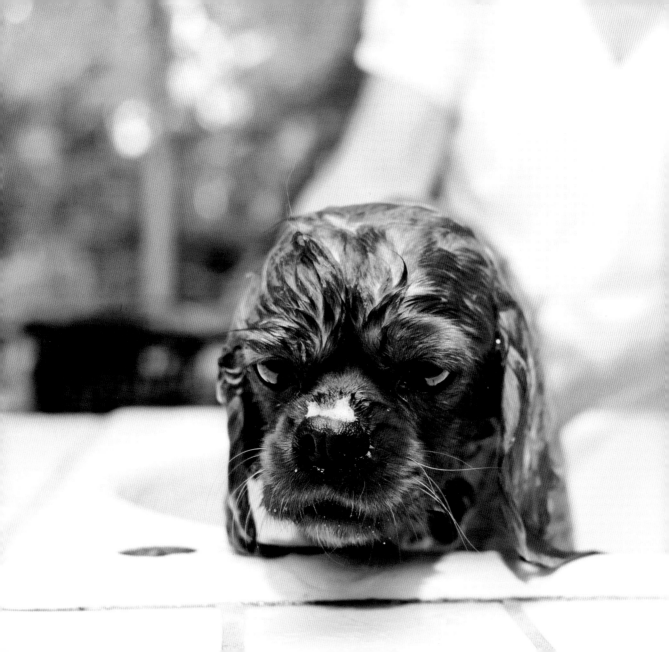

I can look after myself, Mum!

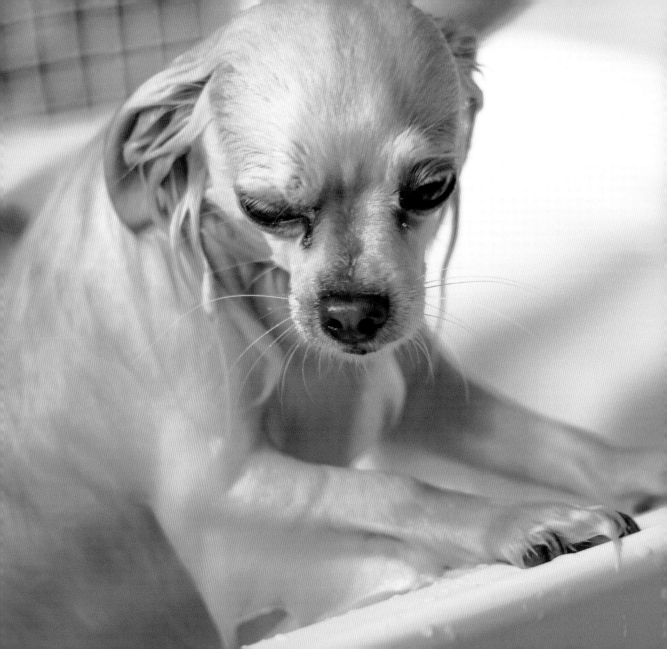

One day, I will make
you pay for this

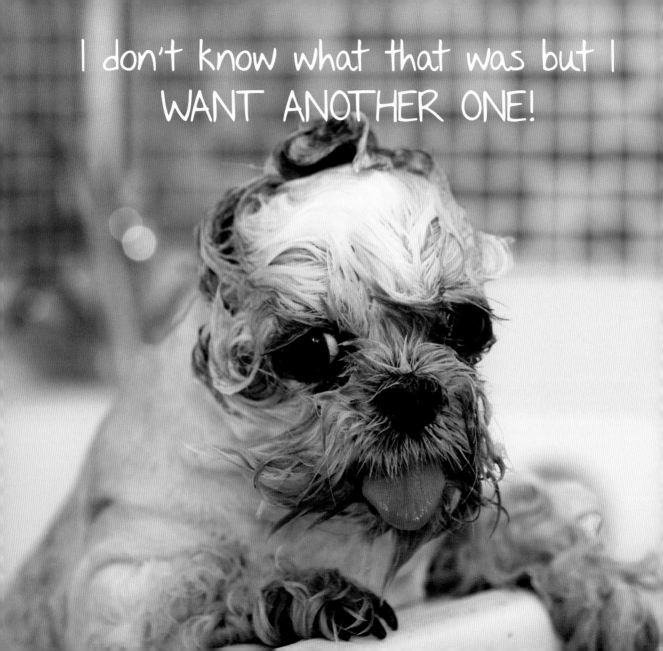

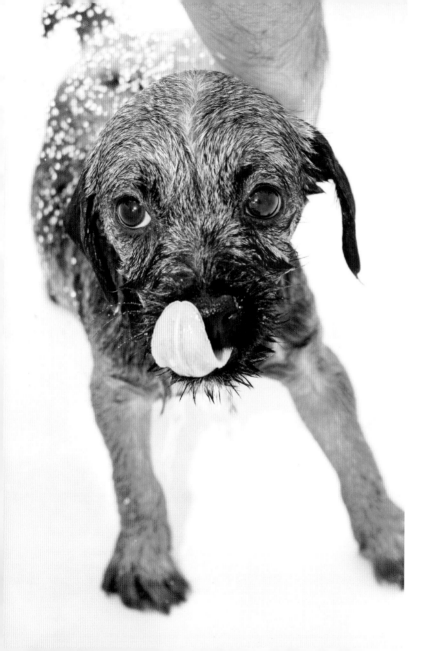

So, am I
going to
smell as
good as I
taste?!

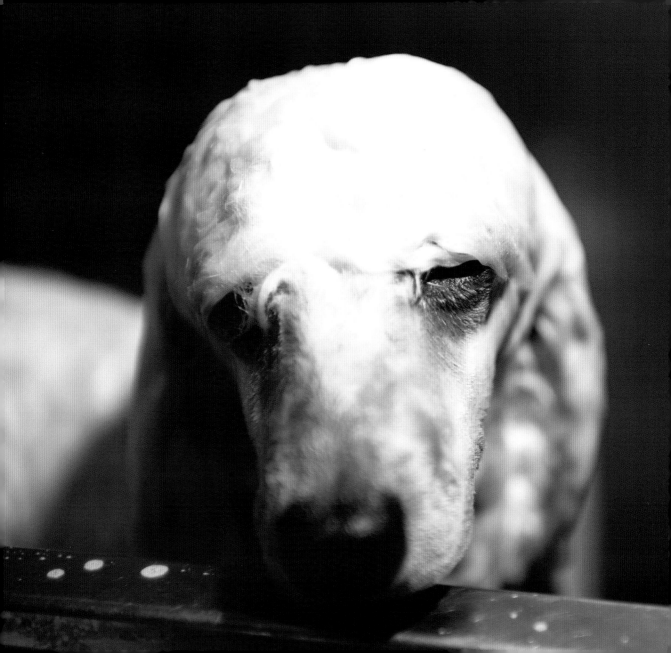

All I want to know is - when did you stop loving me?

Now what happens?

But I thought
you liked me?

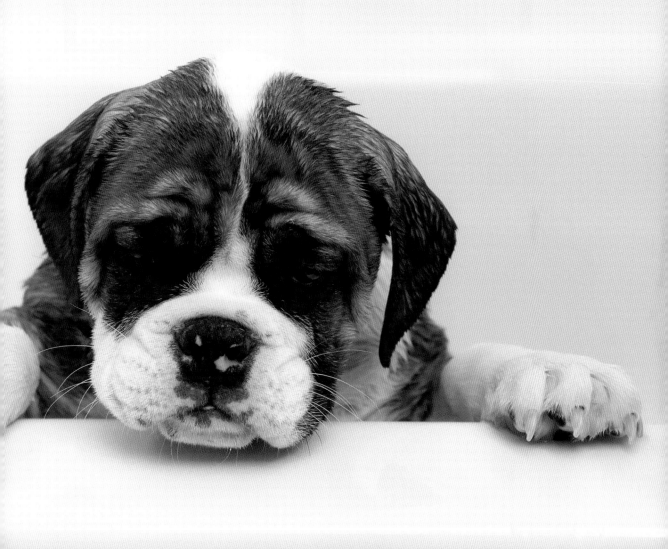

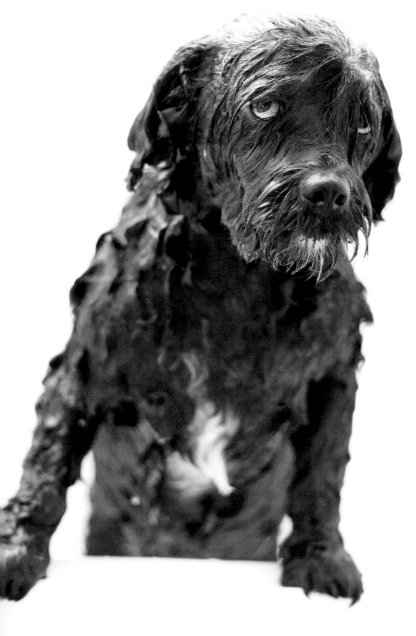

Nothing about
this is ok

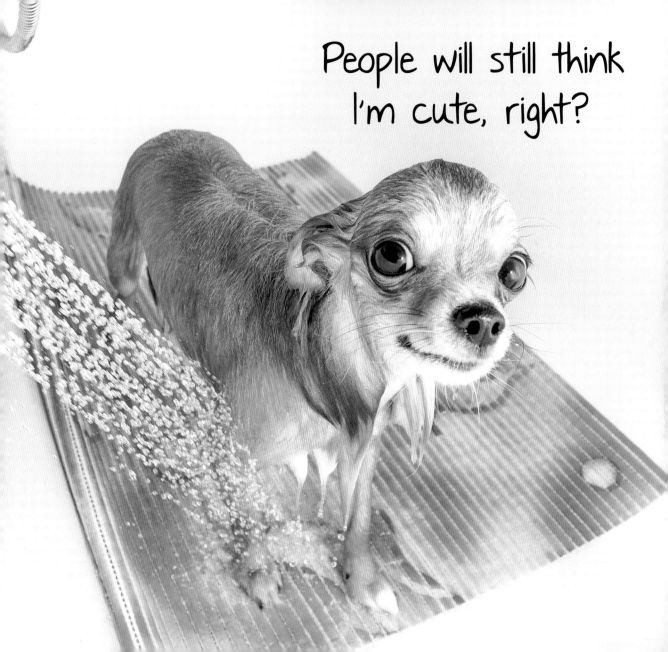

People will still think
I'm cute, right?

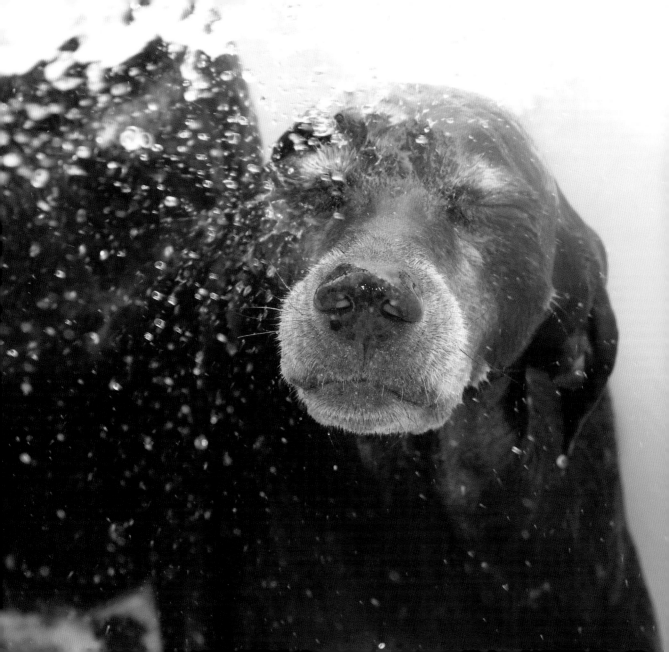

I might not look like
I'm enjoying this, but I
REALLY AM!

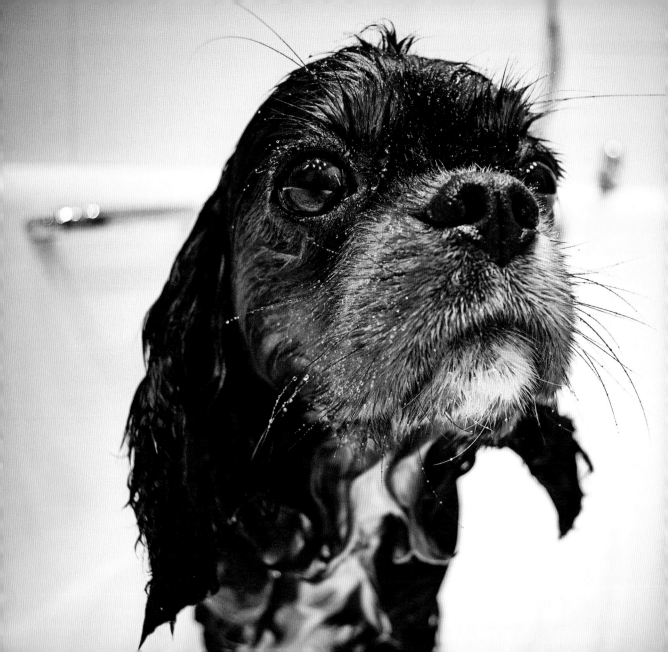

I promise I'll never
get dirty again...

It's times like this that I really begin to question my own sanity

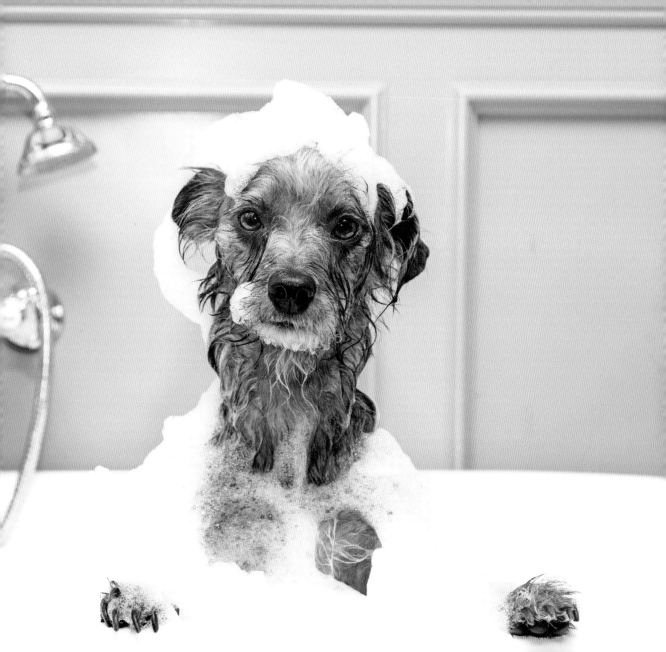

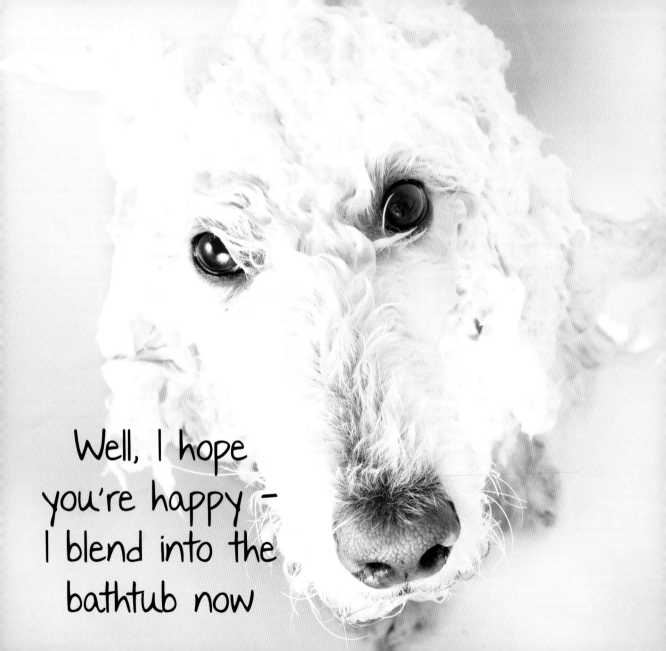

Well, I hope
you're happy -
I blend into the
bathtub now

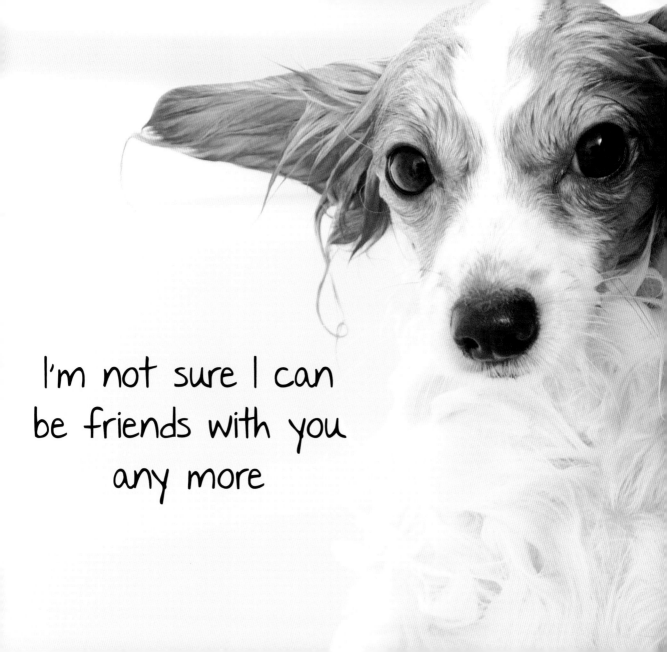

I'm not sure I can
be friends with you
any more

Can we use
the strawberry
shampoo again?
Pretty please?

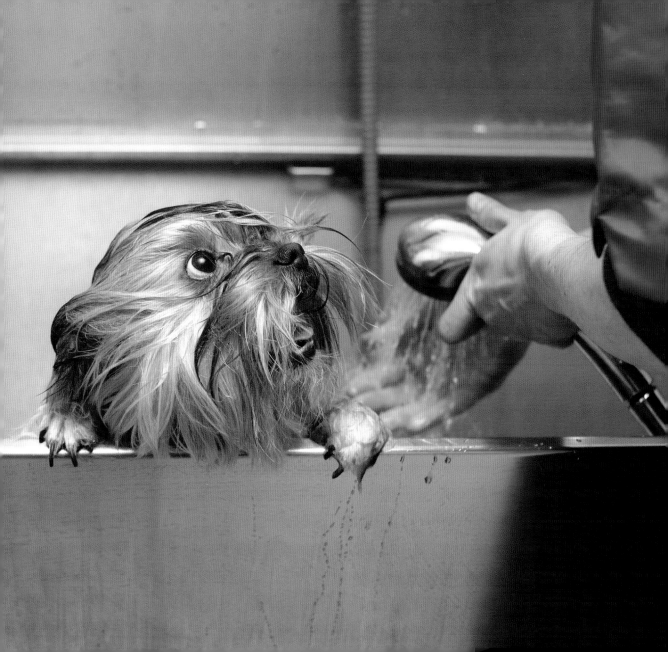

This is not what I
had in mind when I
said I wanted some
'me time'

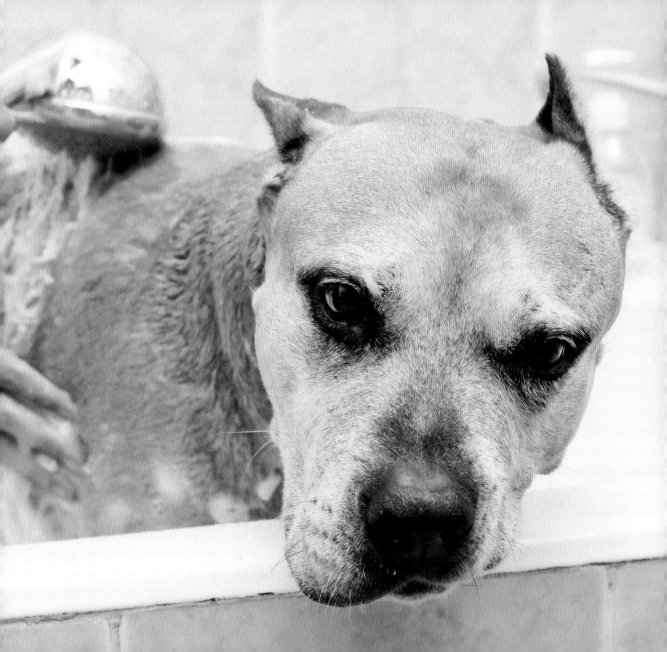

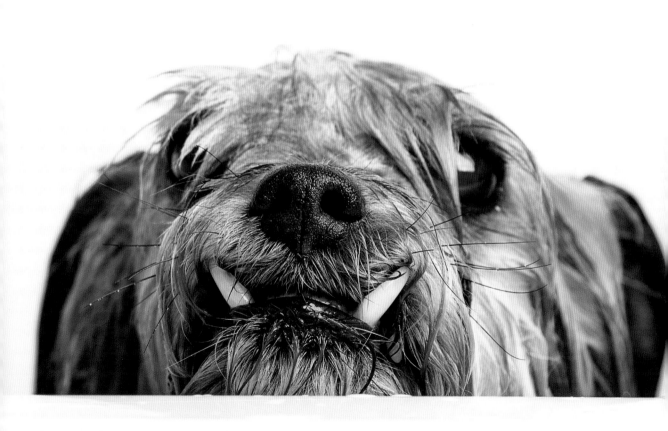

Tell me it's over...

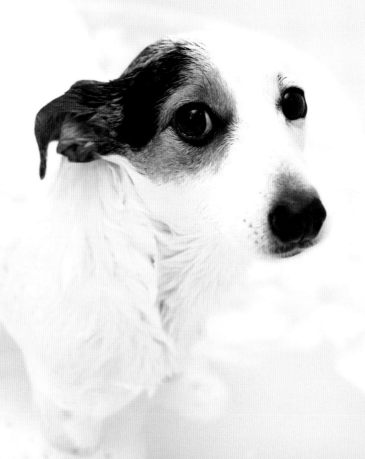

Would you make me a
beard out of bubbles?

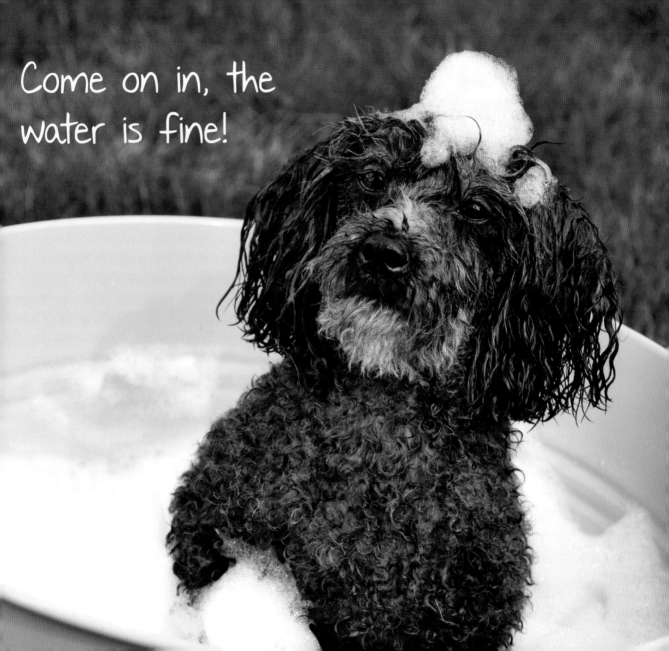

Come on in, the water is fine!

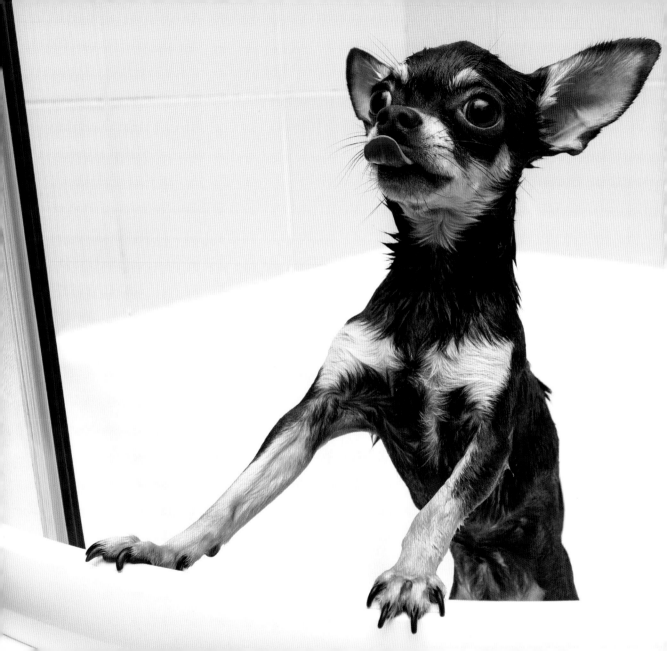

I'm ready for my close-up!

I'm just using this time to think of different ways I could kill you

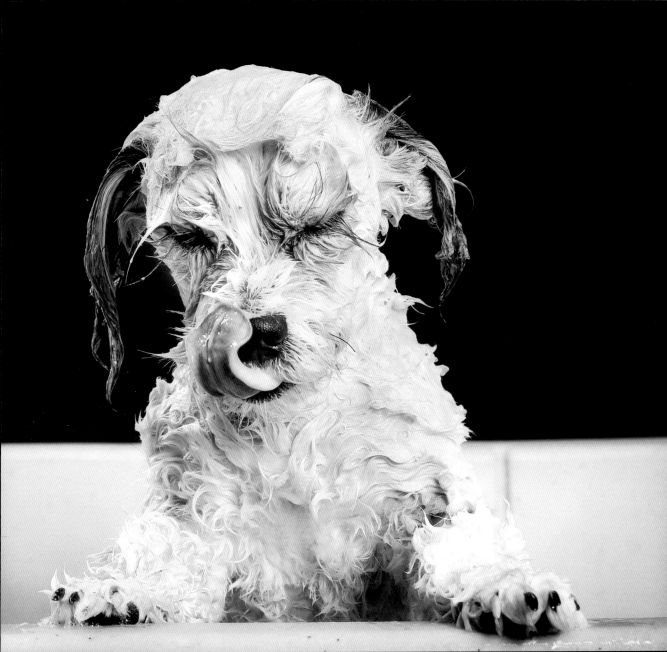

You have to get
me out of here. I
think something just
touched my leg!

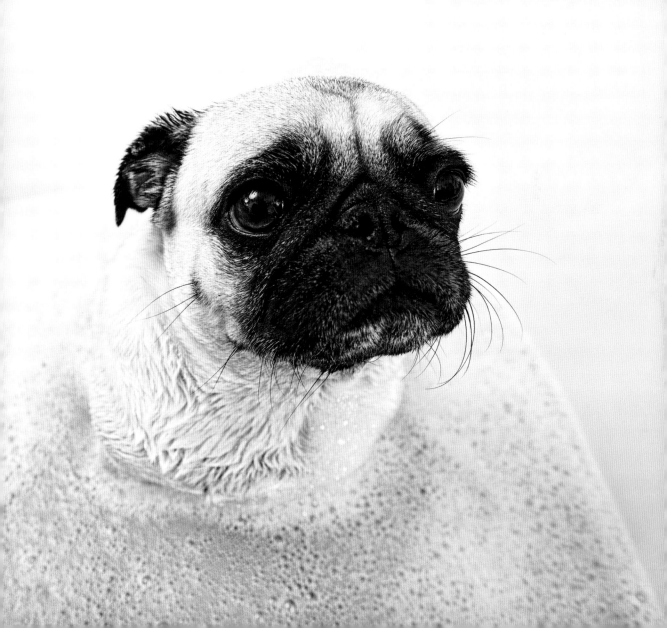

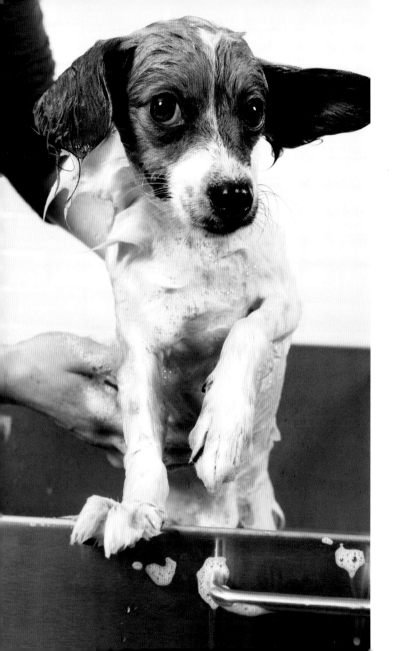

I've been very patient with you, but I'm reaching breaking point

I LOVE
THIS. I
LOVE THIS
SO MUCH.

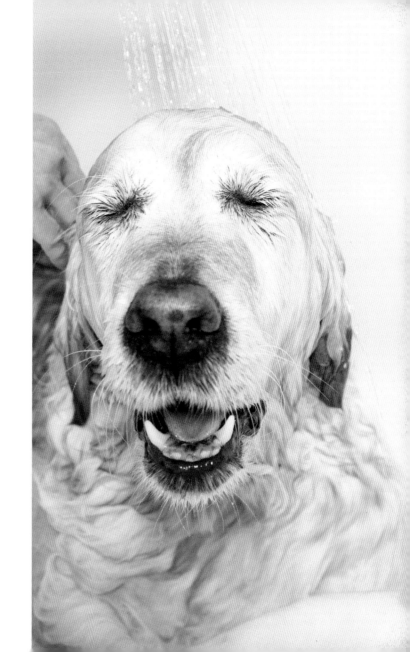

Get me out of
here this second
and let us
never speak of
this again

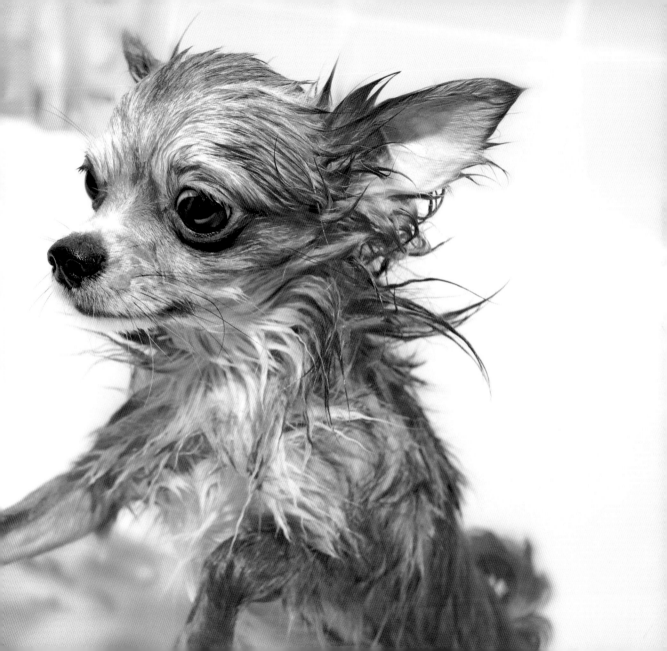

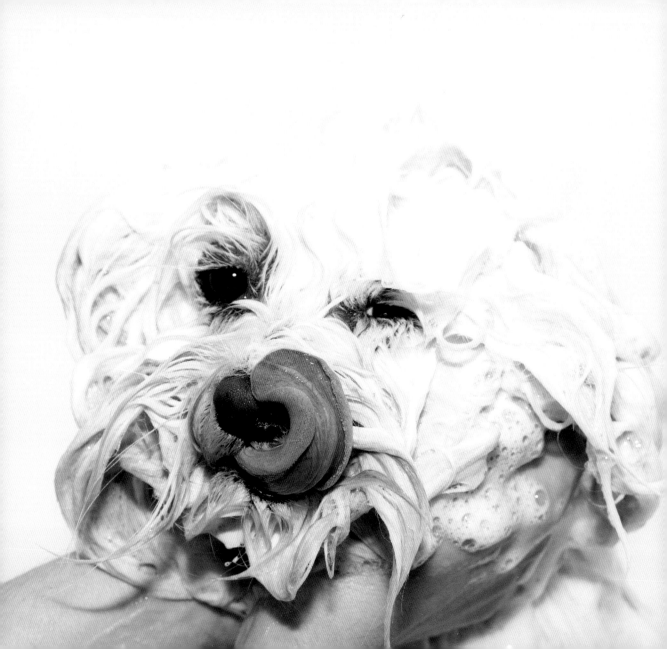

Just think about dinner. Focus on dinner.

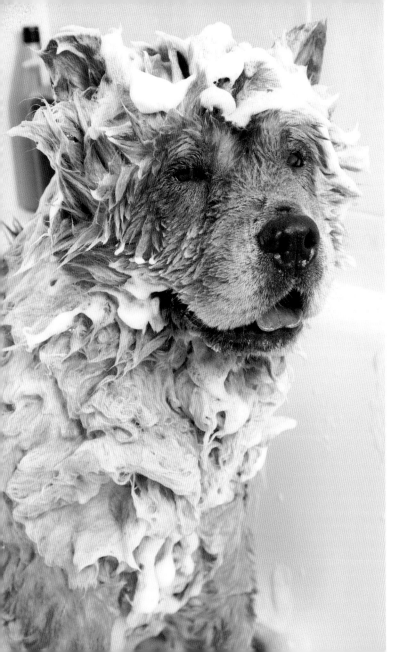

Pretty
confused
about
the whole
situation, to
be honest

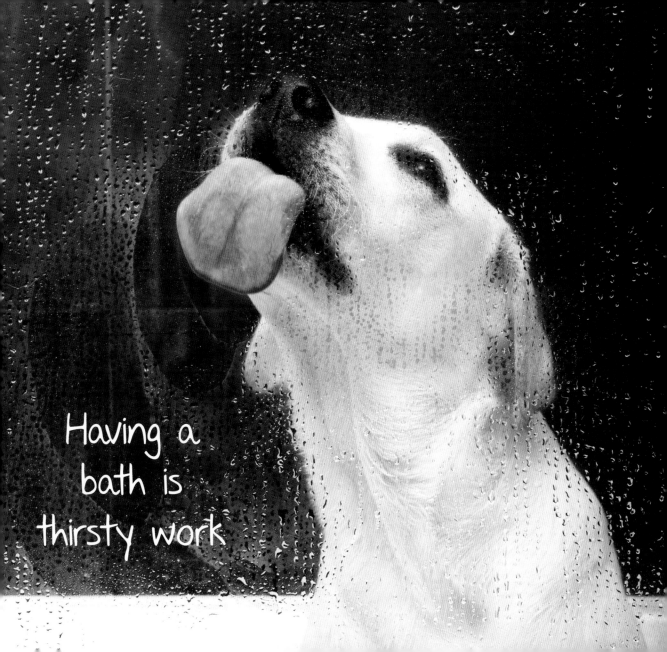

Having a
bath is
thirsty work

Can we try an anti-wrinkle mask?

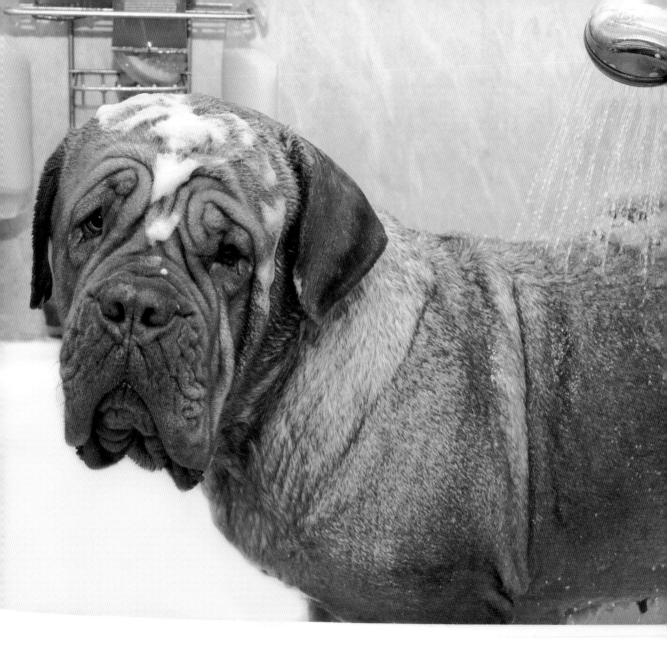

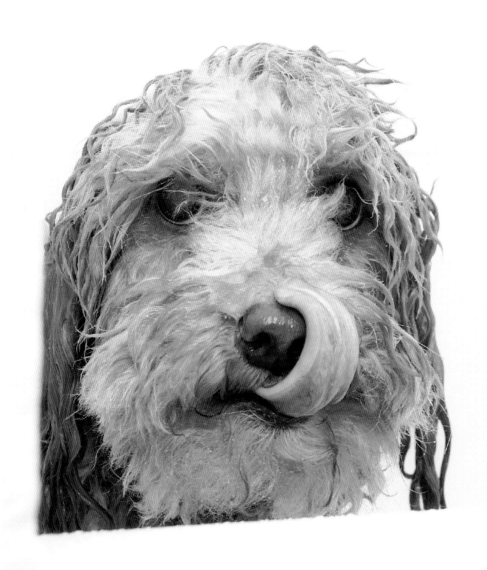

Please restore me to
my normal fluffiness
at once!

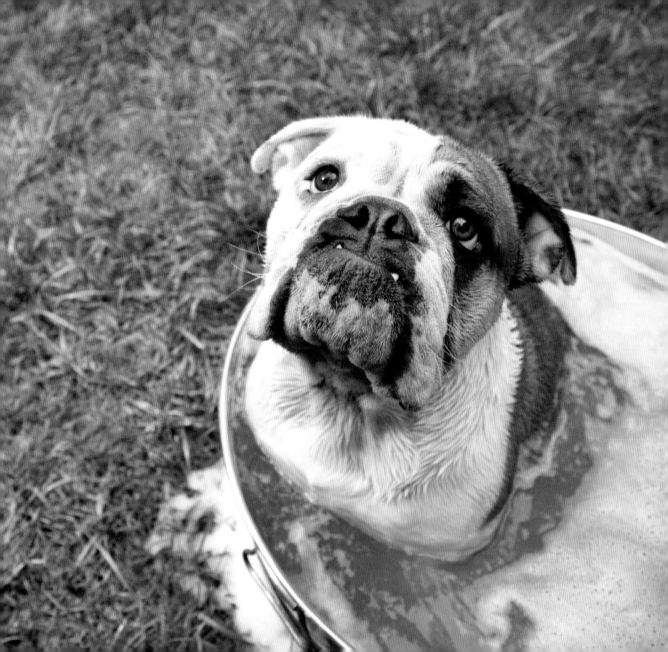

Am I clean yet?

Feeling pretty
ashamed of
myself right
now, but
loving it!

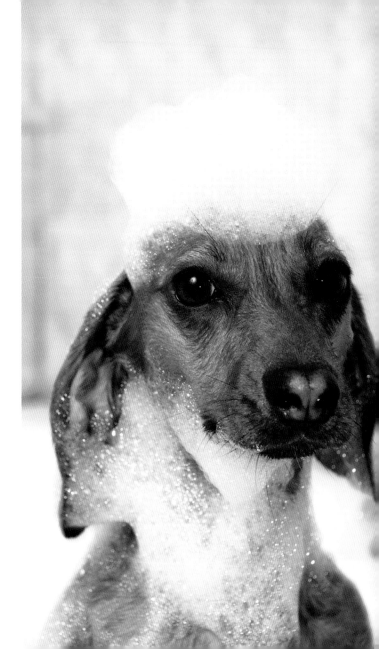

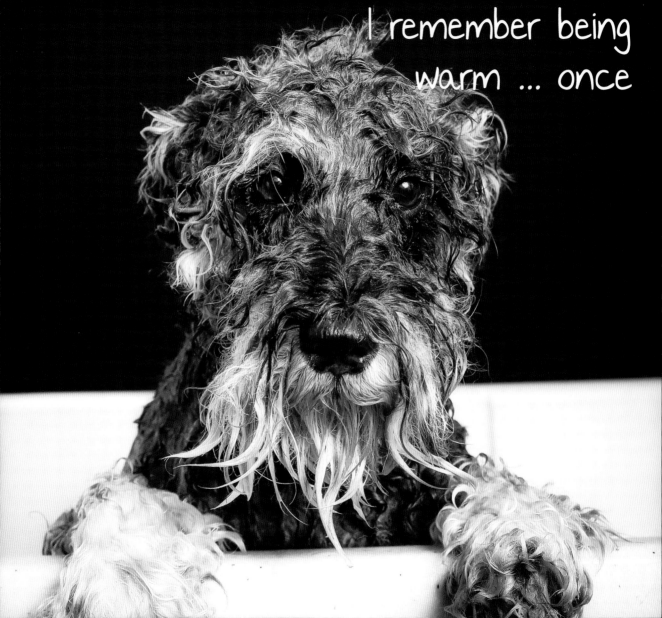

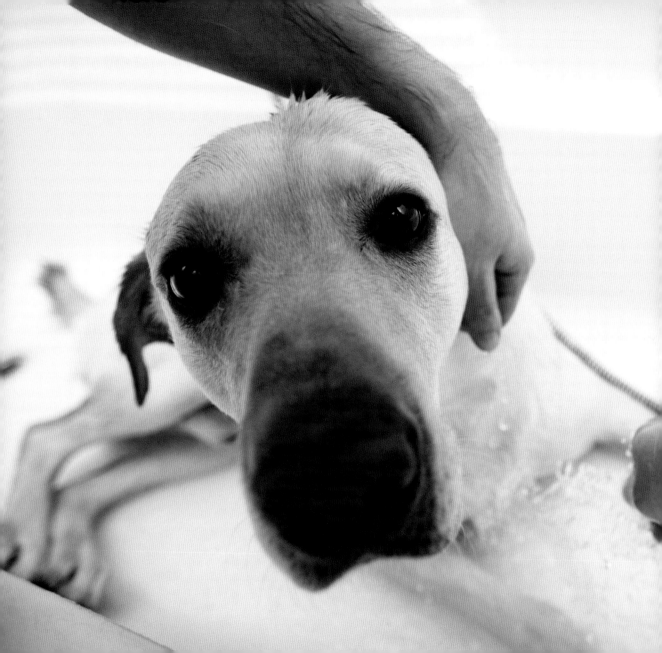

All I ever did was
love you...

Look me in the eye and tell me why you have done this

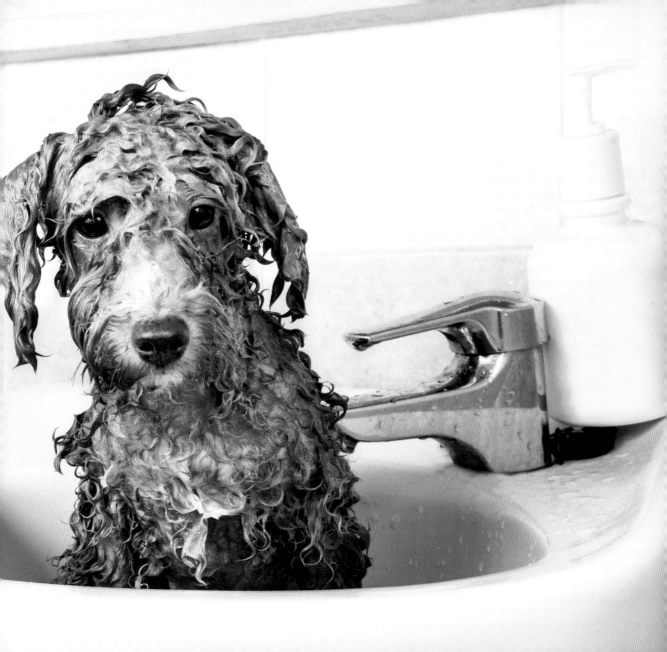

So, I was thinking
of going for a
complete restyle.
Just do what you
think will suit me

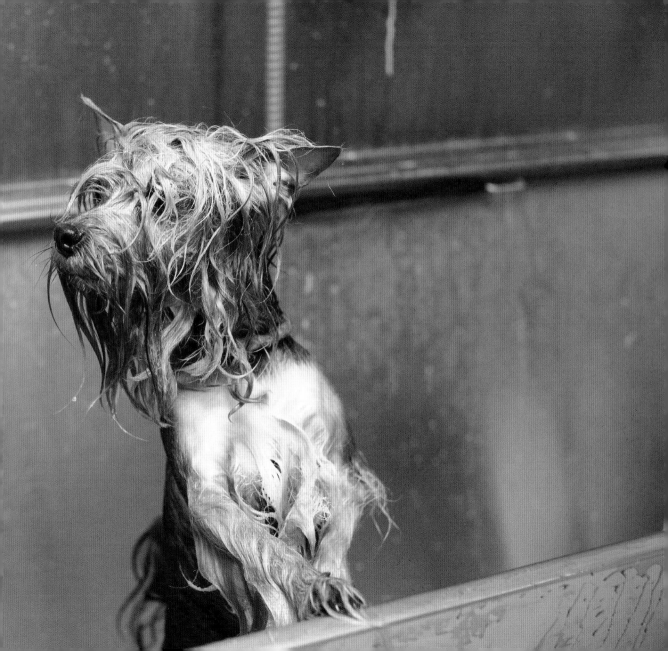

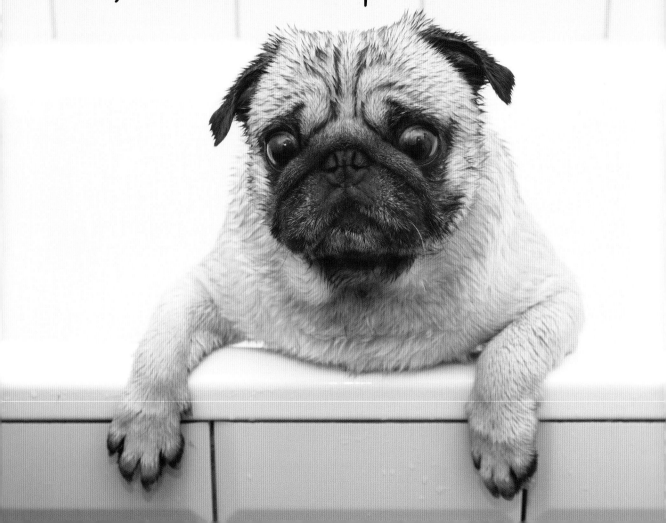

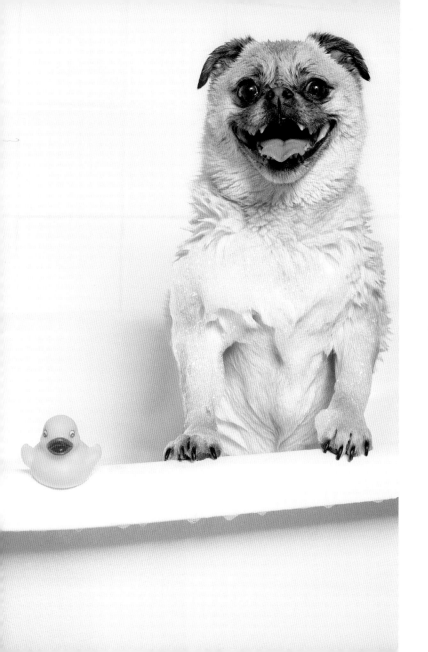

I AM JUST
HAVING THE
BEST TIME
EVER

127

I have no words

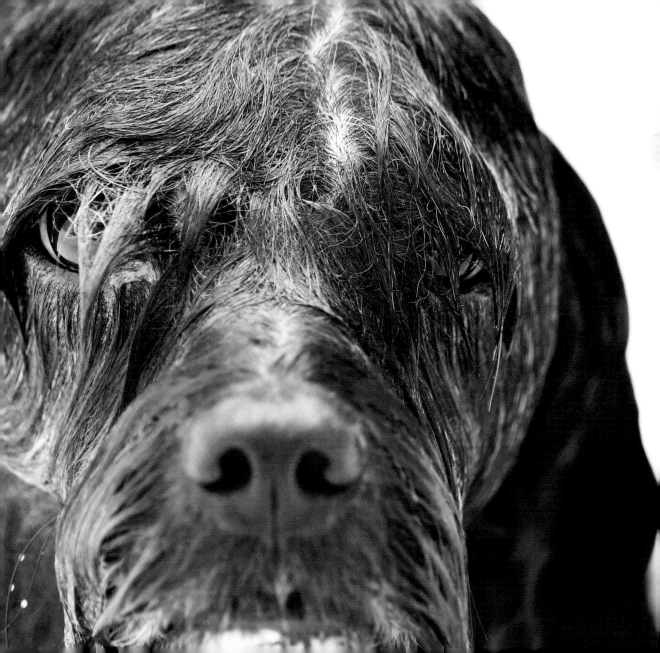

Nothing like a long
soak in a hot bath
after a hard day
chasing cars

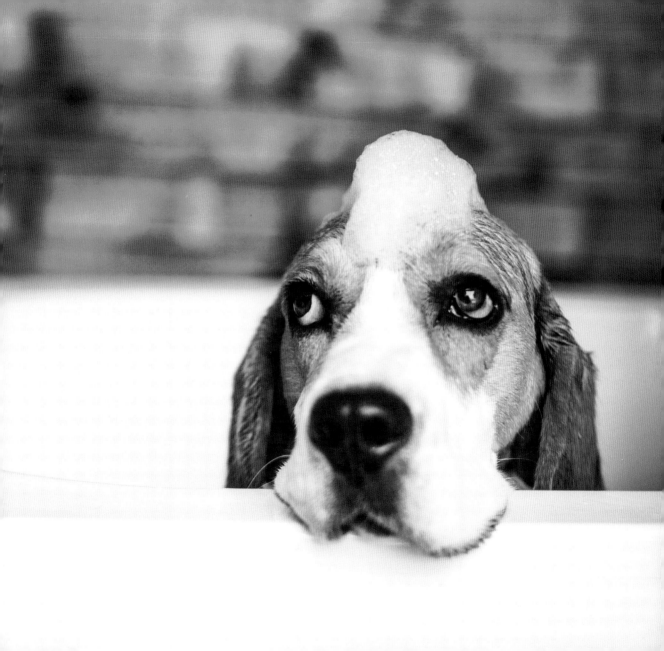

Fetch me a towel.
THIS. INSTANT.

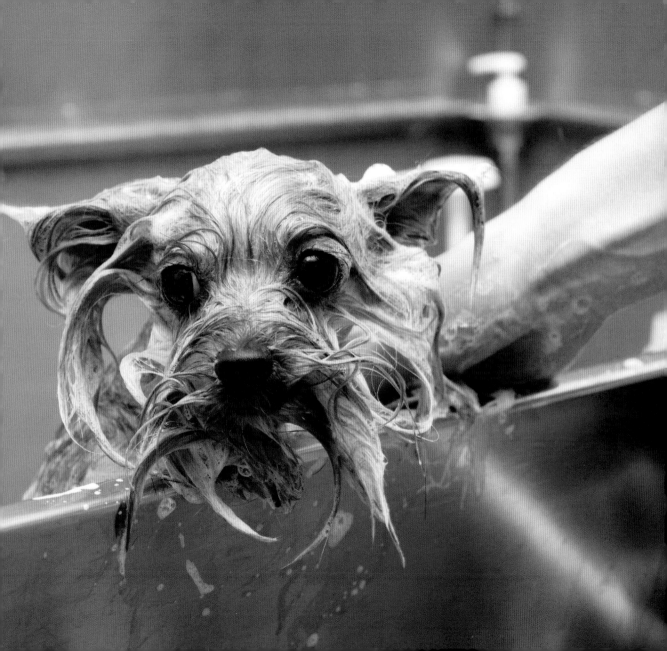

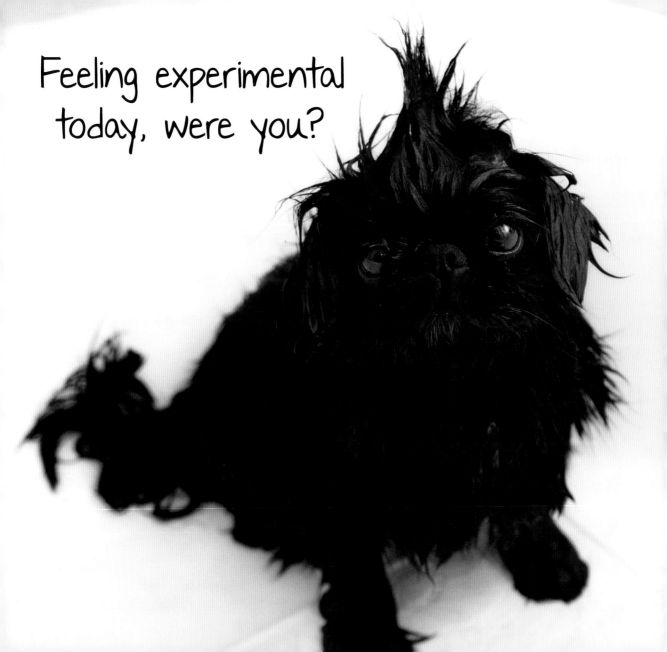

Feeling experimental today, were you?

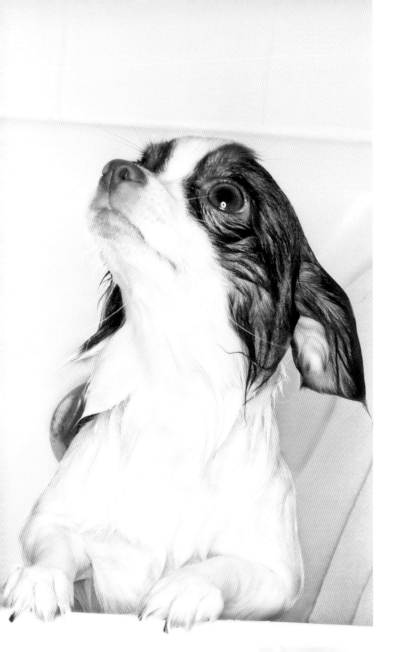

Right, let's get this over with, I have lots of sticks to fetch and cats to terrorise

135

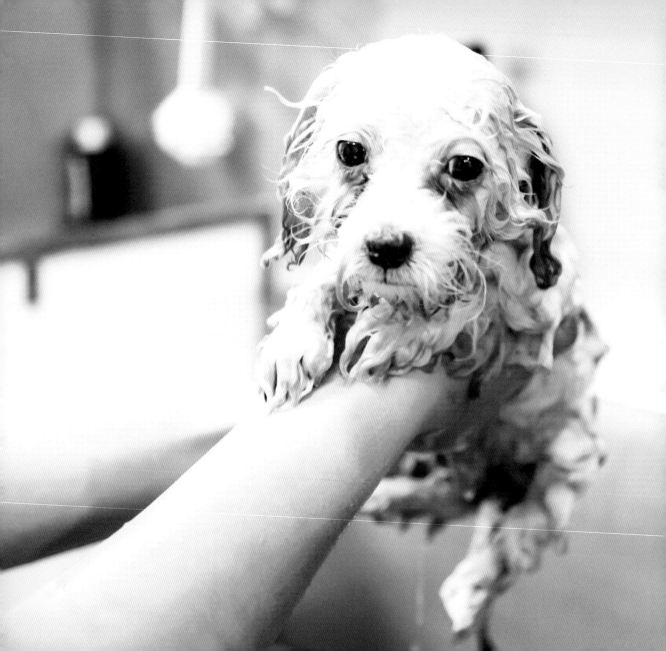

Look at my tiny face. This is what sadness looks like.

Don't look at me!

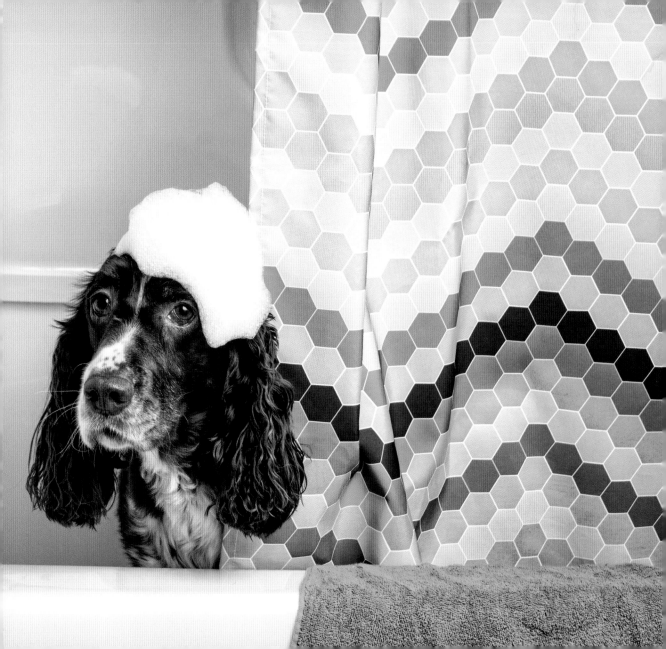

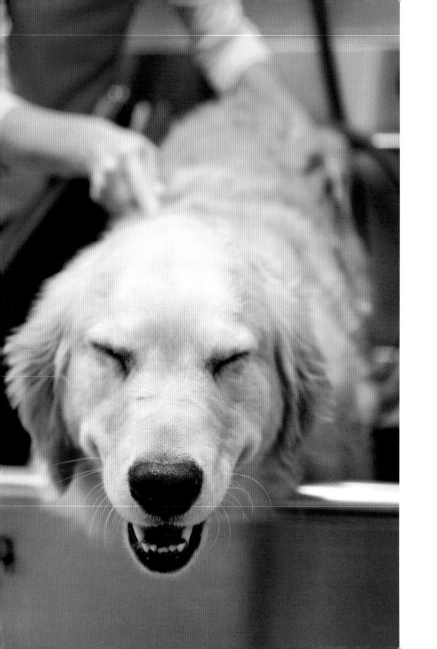

Stop, it tickles! No, keep going!